THE SEA WITCH

copyright © 2022 By **Matt Leyshon**

Matt Leyshon asserts the moral right to be identified as the author of this work.

First published by
INCUNABULA 2022

all text and images by **Matt Leysho**n

ISBN: 978-1-4710-8436-2

www.incunabulamedia.com

THE SEA WITCH — PHOTOS and TEXT by MATT LEYSHON

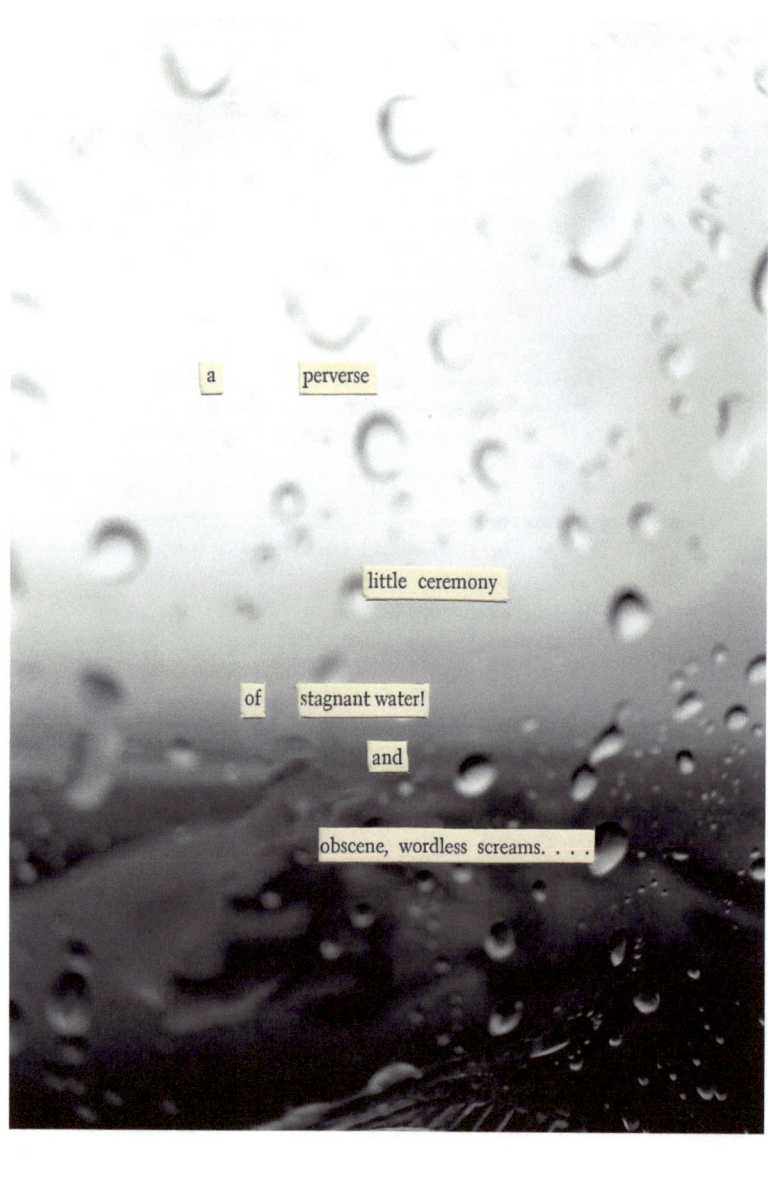

a perverse

little ceremony

of stagnant water!

and

obscene, wordless screams. . . .

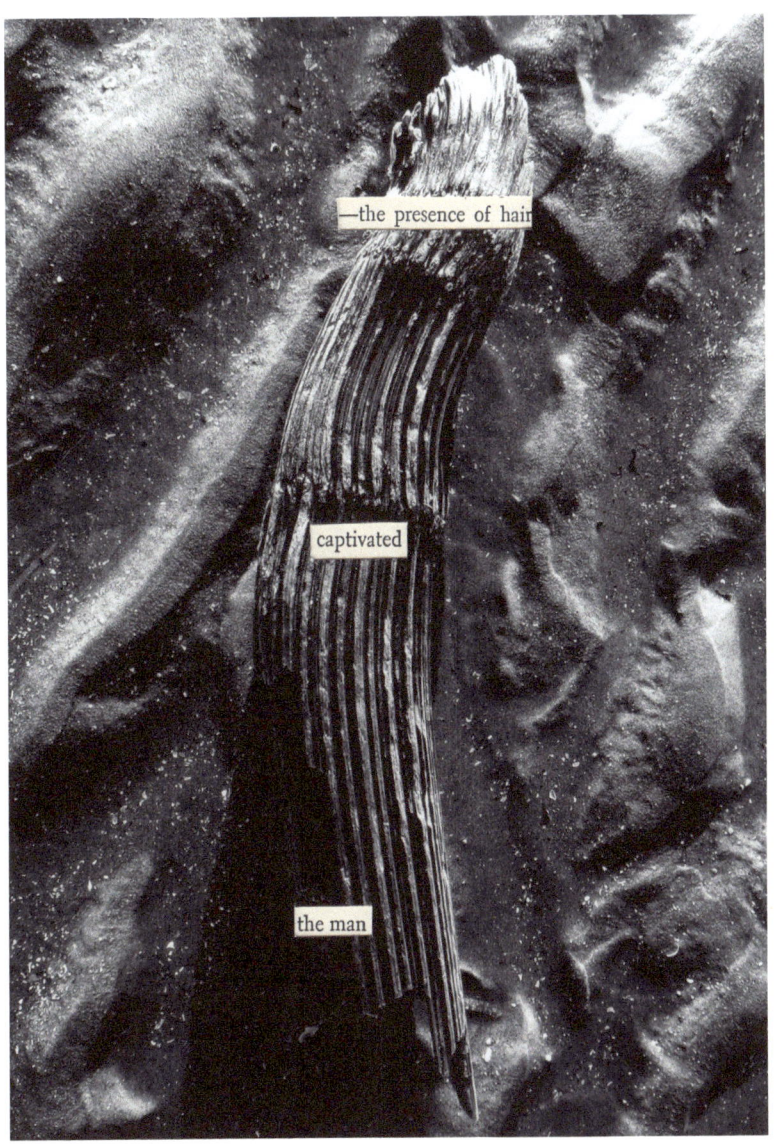

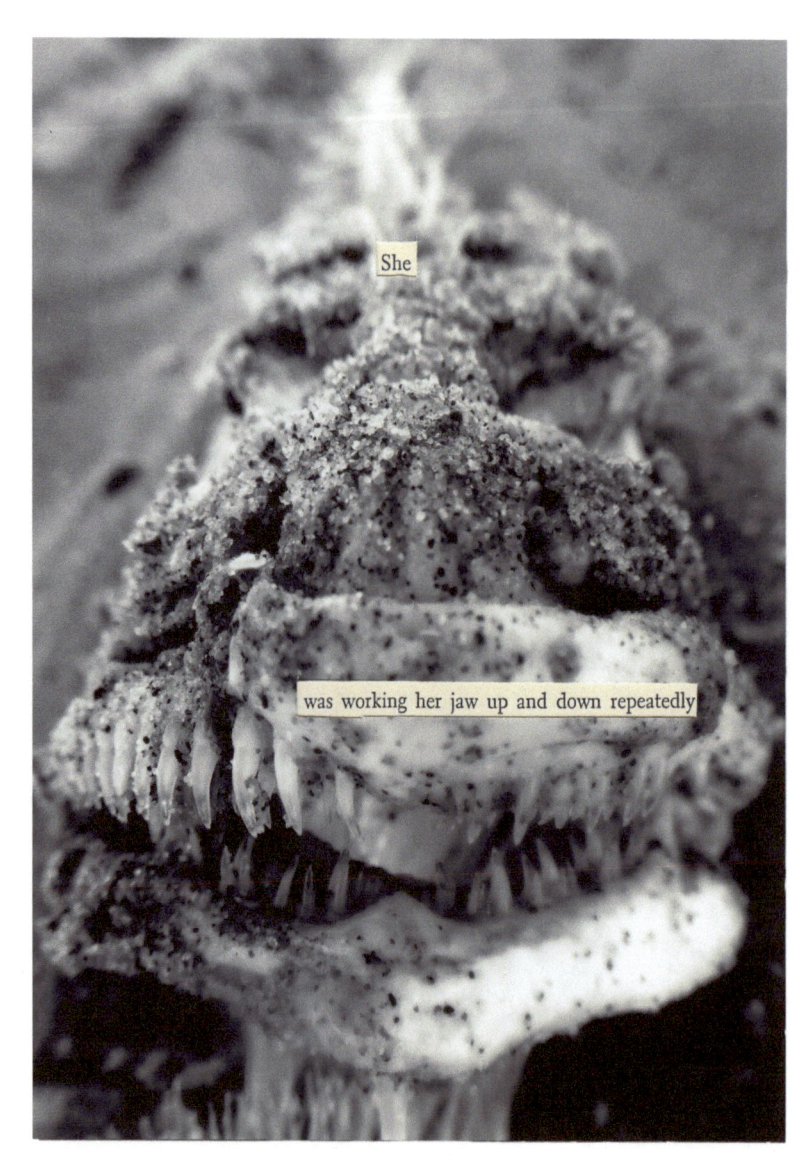

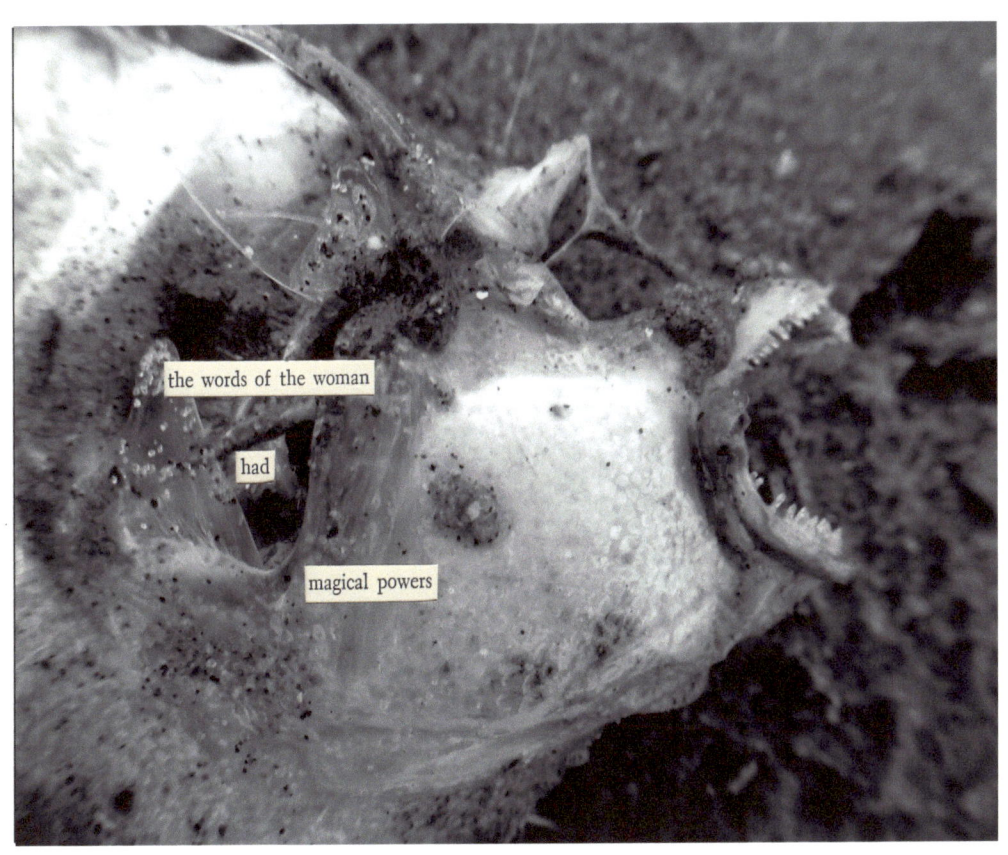

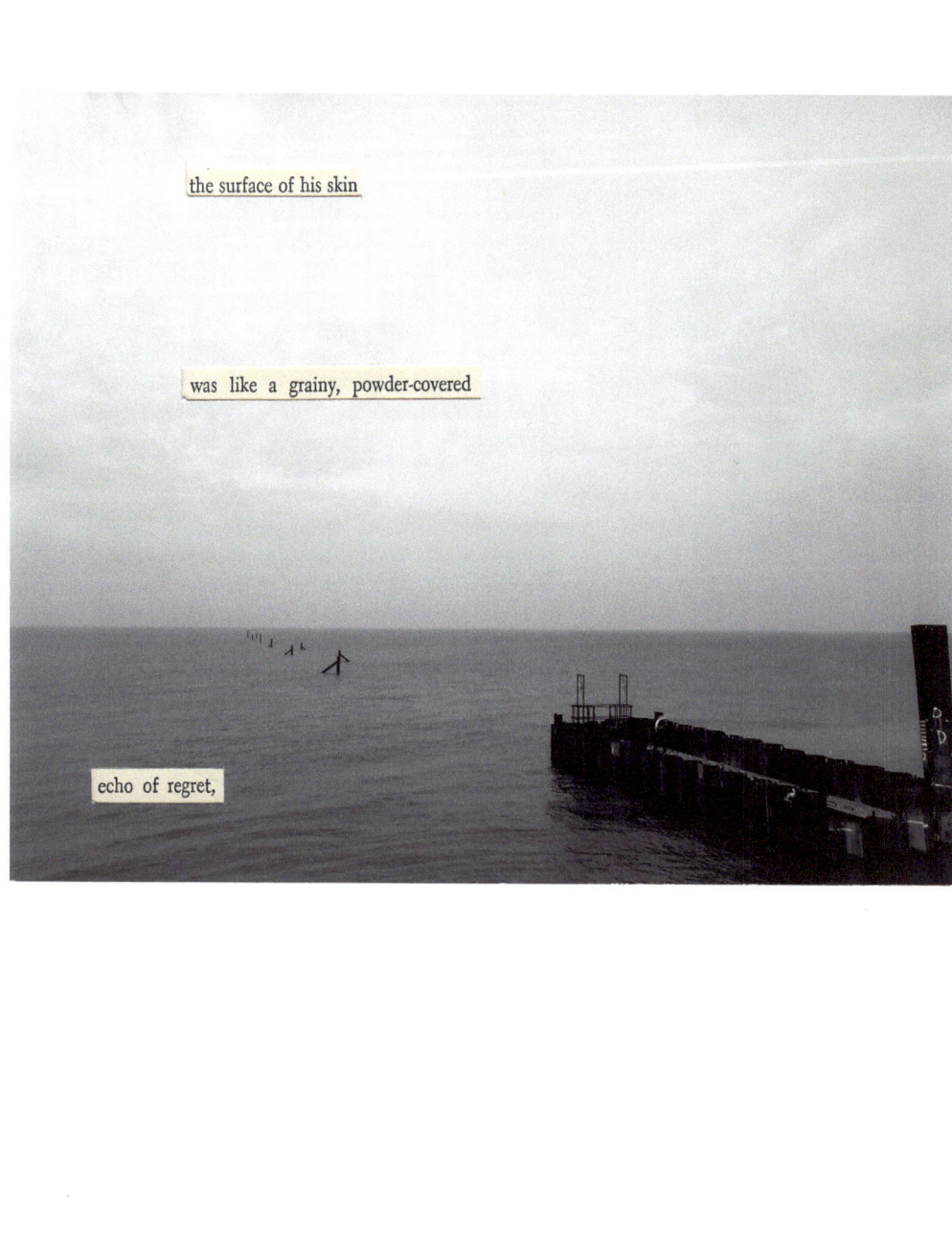

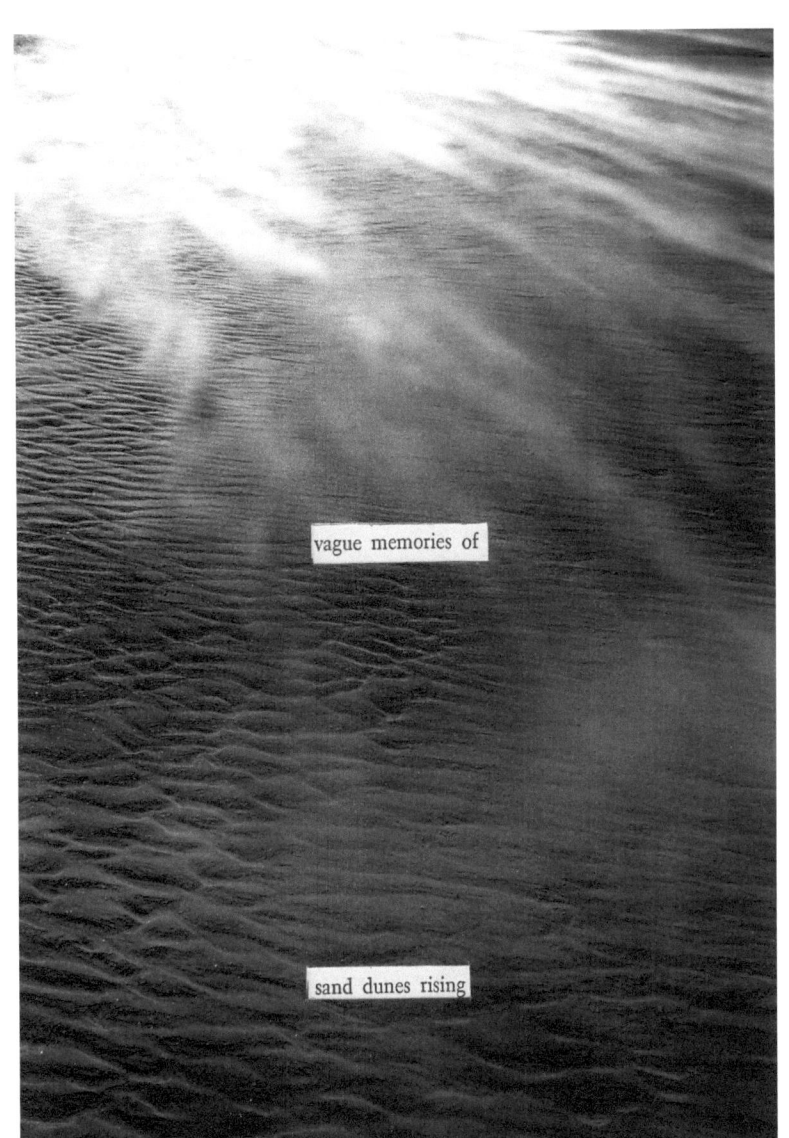

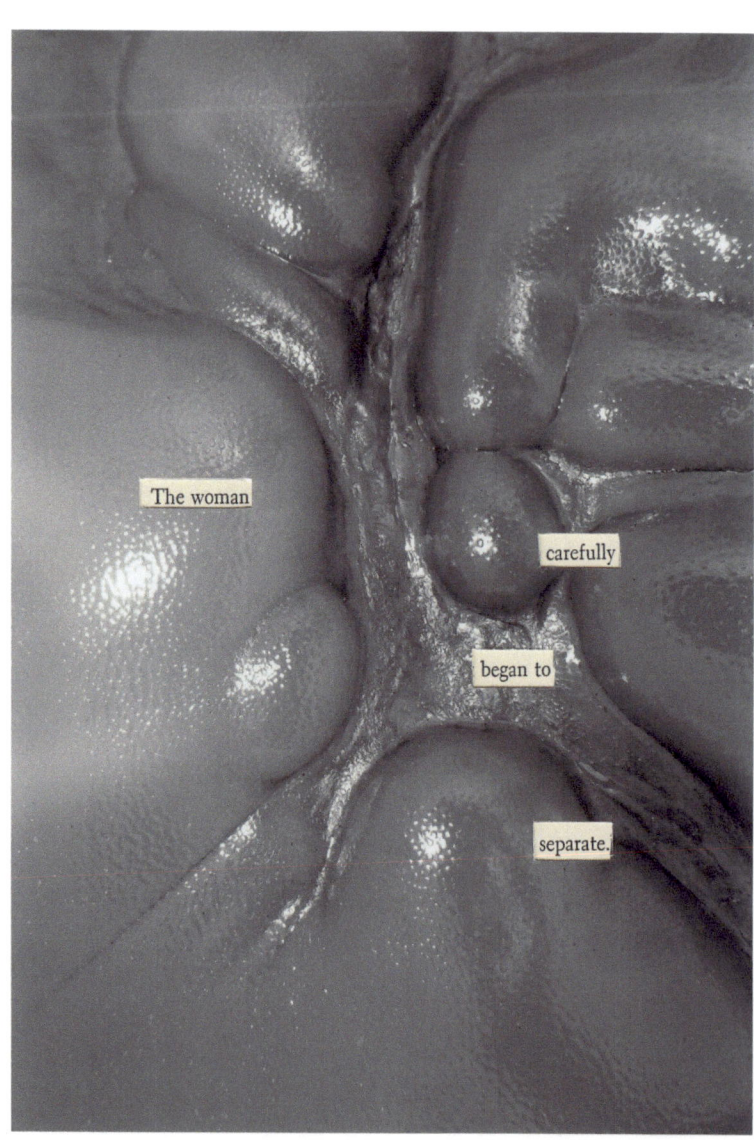

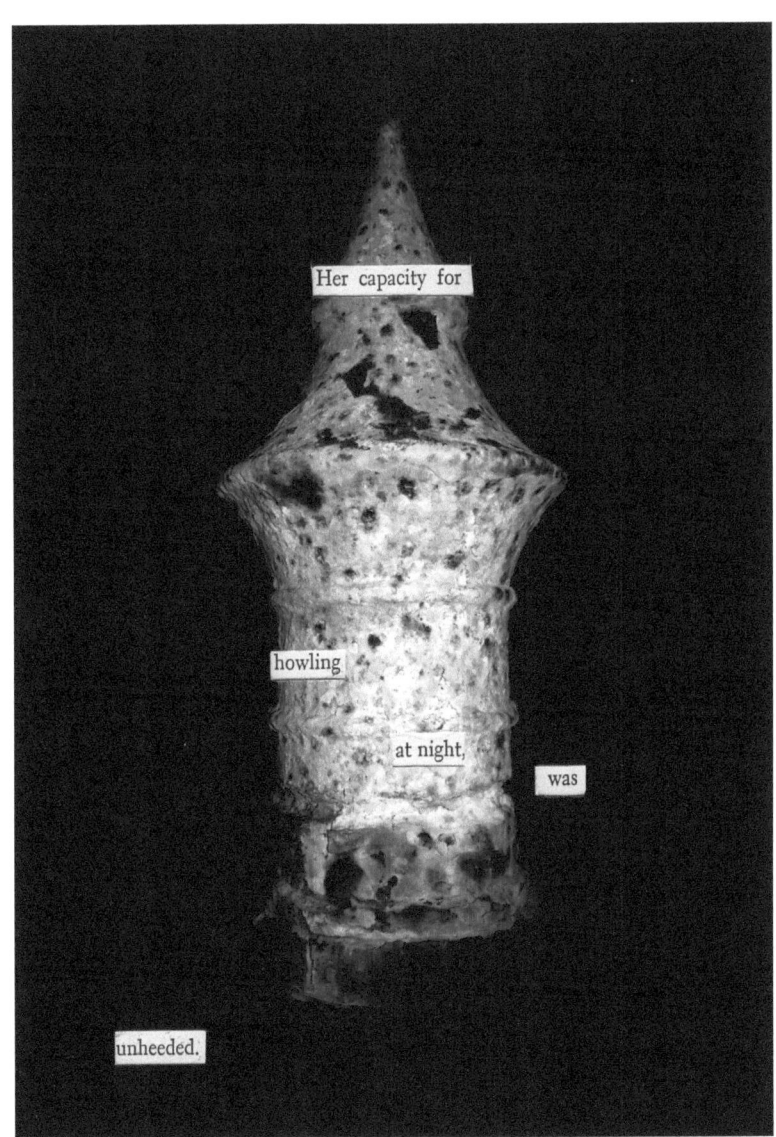

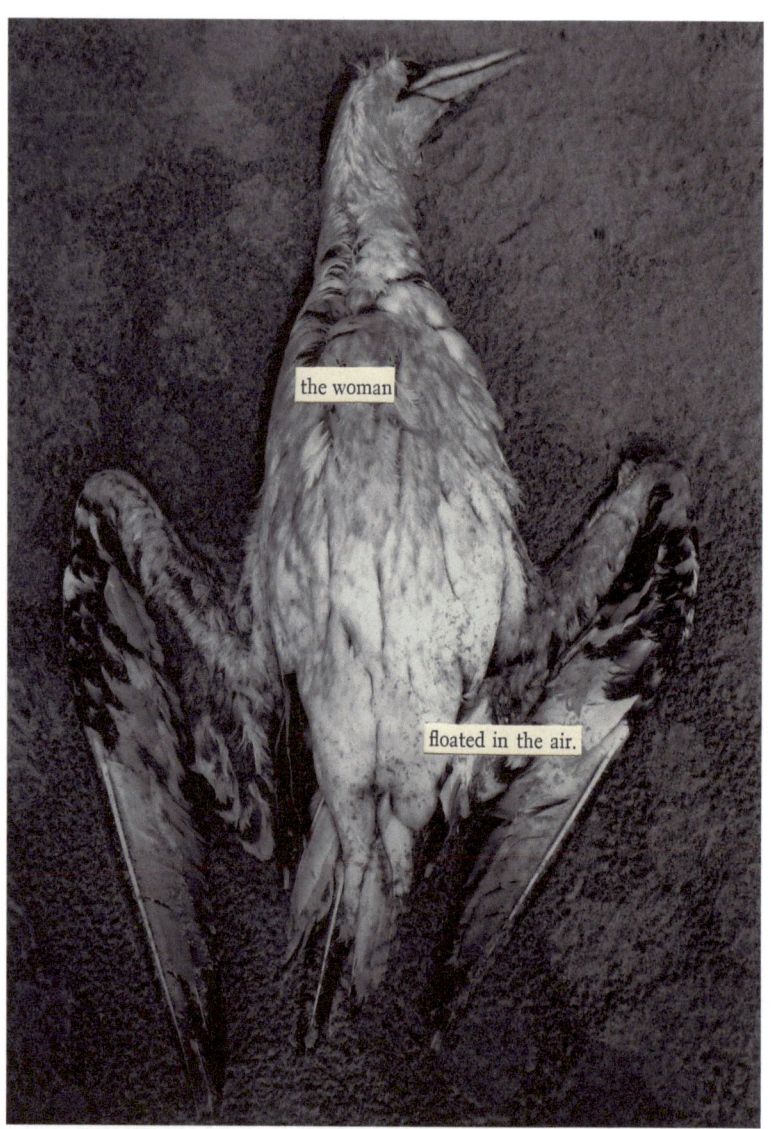

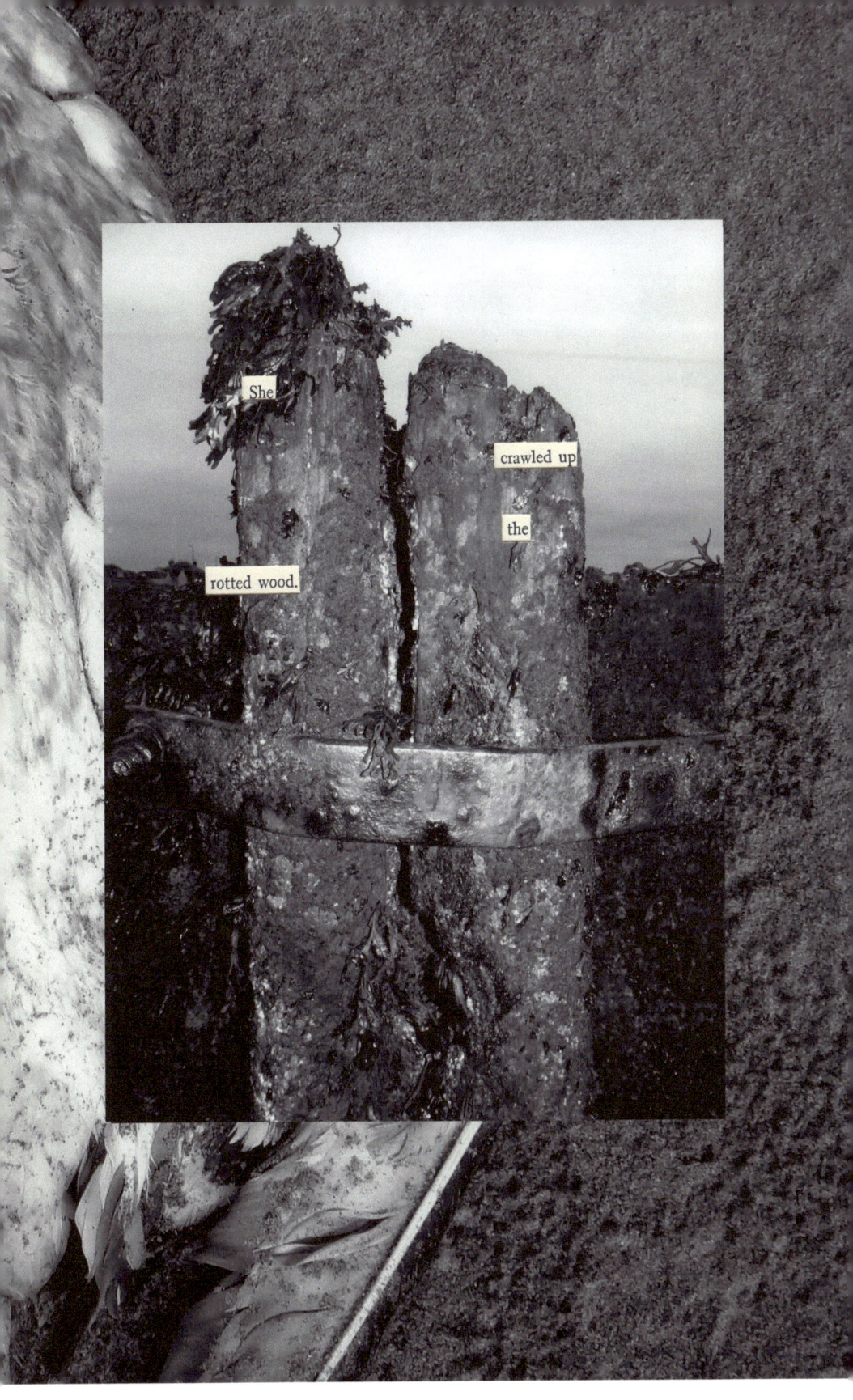

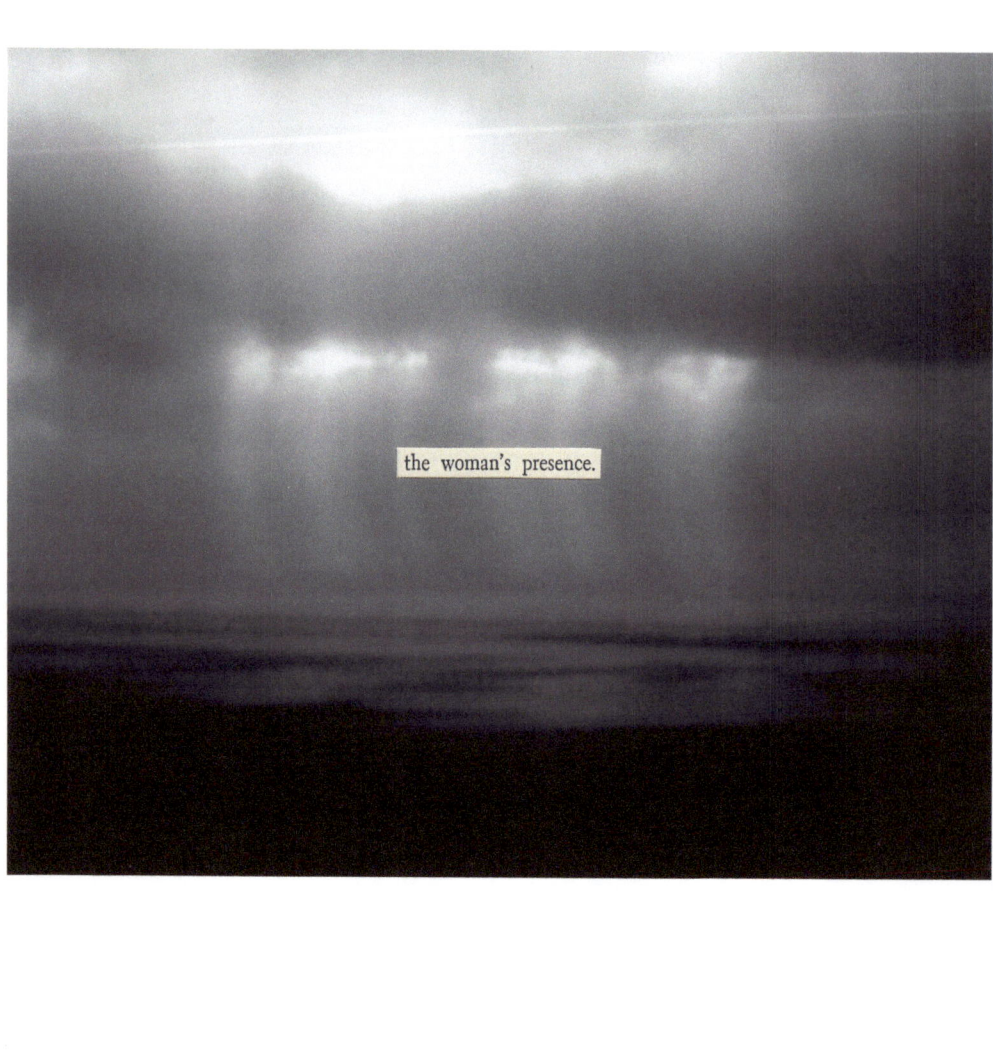

The Sea Witch

He passes through seas of musk following the hair-dredged paths of the sea witch. He looks out for everything as far as the horizon where red tongues flit in robes of flame. The flow of his shadow is buried at his feet. Alcove shapes of hair extend like wine into the sand between his toes. He is lost among autumn tresses, bowing and shaking his eyes in the air – I imbibe my love with colour. He plucks dandelions from the sleeves of gliding gulls. He is lulled by the black ocean, the waves at the shoreline, the sand, the finger nail furrows left by her hair, the Mother of Beetles.

The woman is old. She lives alone in her house of tidewrack. She drinks the dust of moth wings in the shadows of the night. She sows stars from jars, leaving strange calligraphy in the sand. Her fragile and wan body inhabits a galloping basement grey of twilight shadows. She closes the mouth of her mouth – Drink deep of my oasis of sand and penions. The nape, o singeless curls, the curlew prints and departing crows, o ecstasy. He is bewitched by the many traces of her presence, of her hair, the Mother of Beetles.

He blames the driftwood knots, foot odours, and the salt-dry darkness. He plunges his head into the pale cage of his shirt collar, heavy with the dampness of sweat and sand. He is drunk on stones from the mermaid's sea. He press-es his ears of azure to the aromatic forest of her door. There is no going back; the wading birds have gorged themselves on her sap. The darkness rises and plays in a circle; a fish mouth of horror. He becomes a strange bird, feathers glistening with the oil of her hair, the Mother of Beetles.

He climbs her doll's body to measure her sickness in idleness – Give me a pavilion of drifting music, of pure and shimmering firmament. She tells him that the Devil shouts the truth at the sea, that he is now a vessel in the swell of her intimate twisted locks, that he is a humping wax image unclenched in her sand flecked thicket. He is aground in a black ocean of fertile hair. She is fringed with down. He sees her ankles open and brighten, reverberating ports with the crackle of burning sails. He is in the witch. His hempen hands melt in the heat of her thighs, mingling with her hair, the Mother of Beetles.

Seagulls float on the infinite rhythms of his memories. Dogs shake sand into his eyes until his shoes are overflowing with grains. He struggles to surface but the tide is of silver heels and spirit. He fixes his eyes on distant masts decorated with pearls, rubies, and sapphires that sparkle in the last of the moonlight. Smoke wheels grow full around the black sharded lady. Her cellar belly turns from the last of the light. He is gone; missing in her mane. Around him there is an ecstasy of sound and scent, and sand of gold and moiré, all deaf to desire. She spoke suddenly as worms burrowed silently - I am the woe manning the dewy ends. He has become all but a figure of speech, a scream in a shock of filaments. The tide is going out and he knows that the only way forward is back into the dark. He clambers deeper into the wet husk of her hair, the Mother of Beetles.

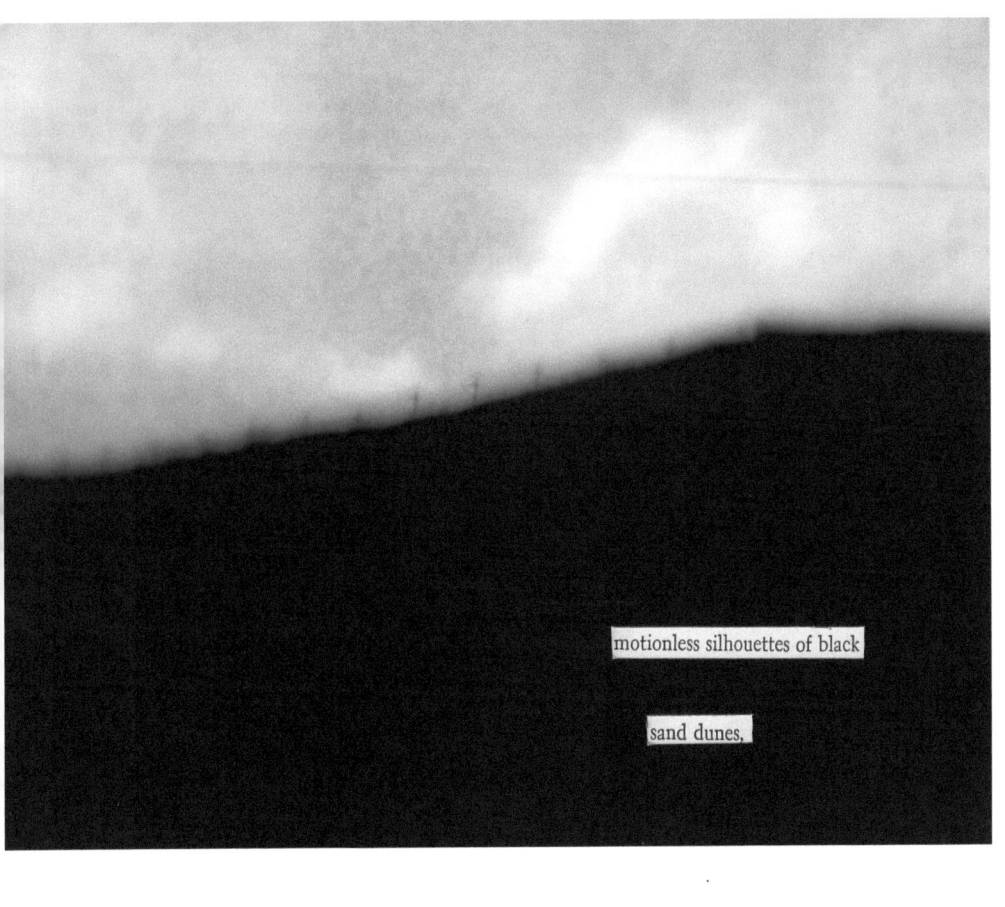

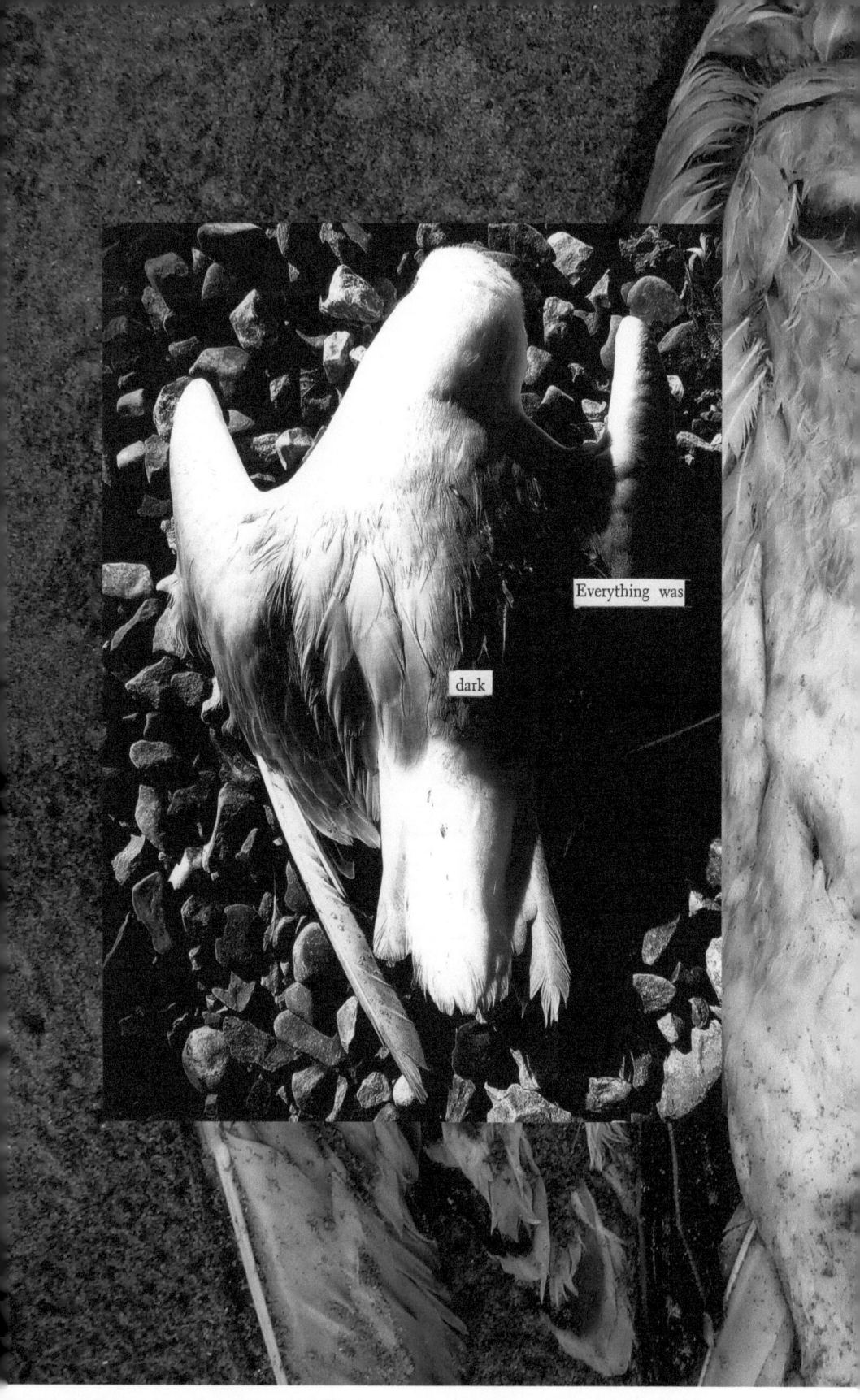

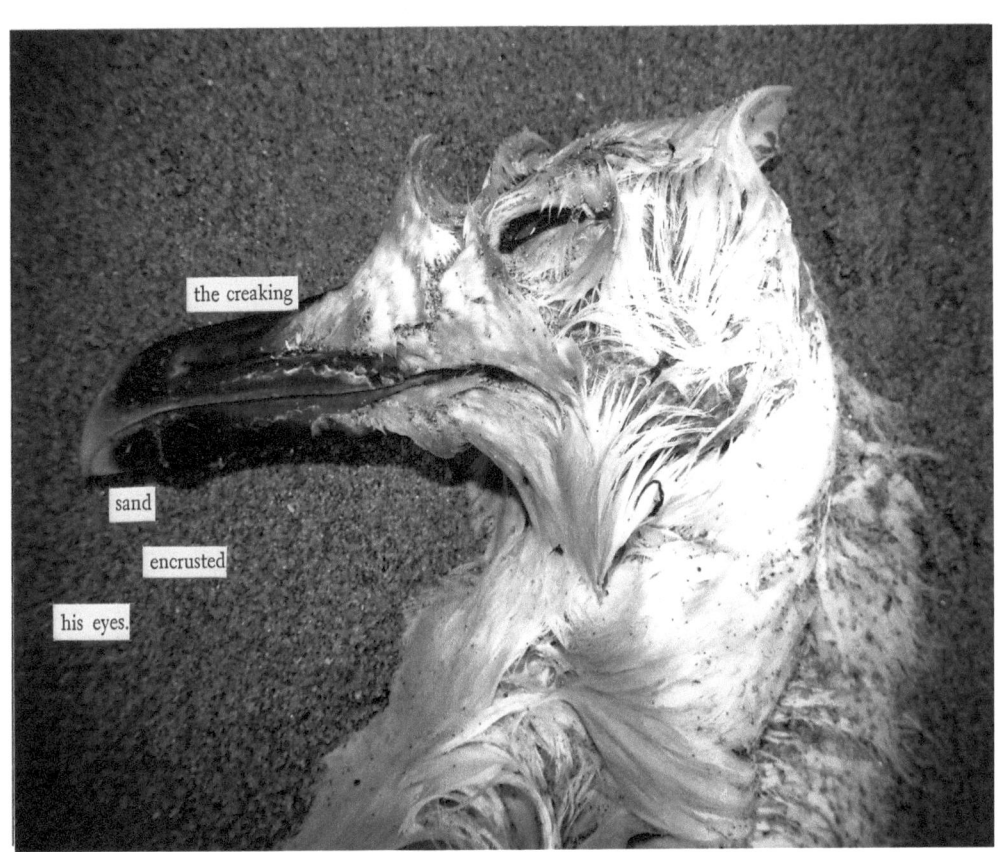

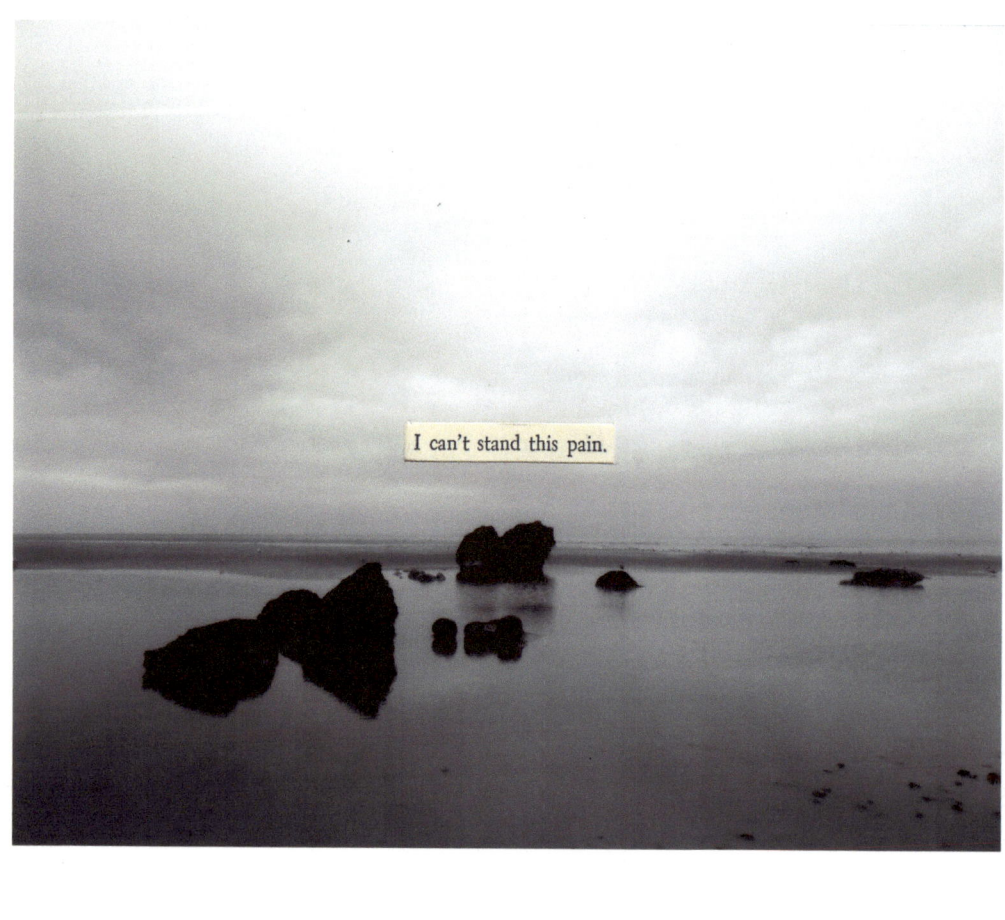

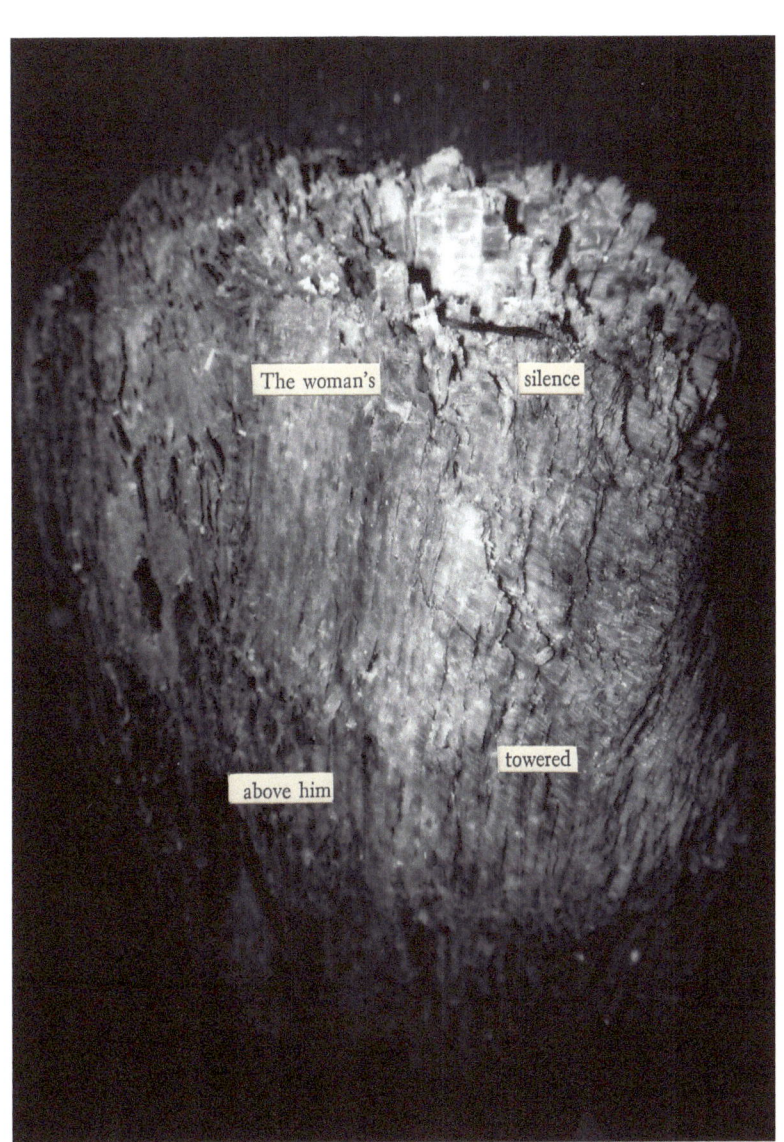

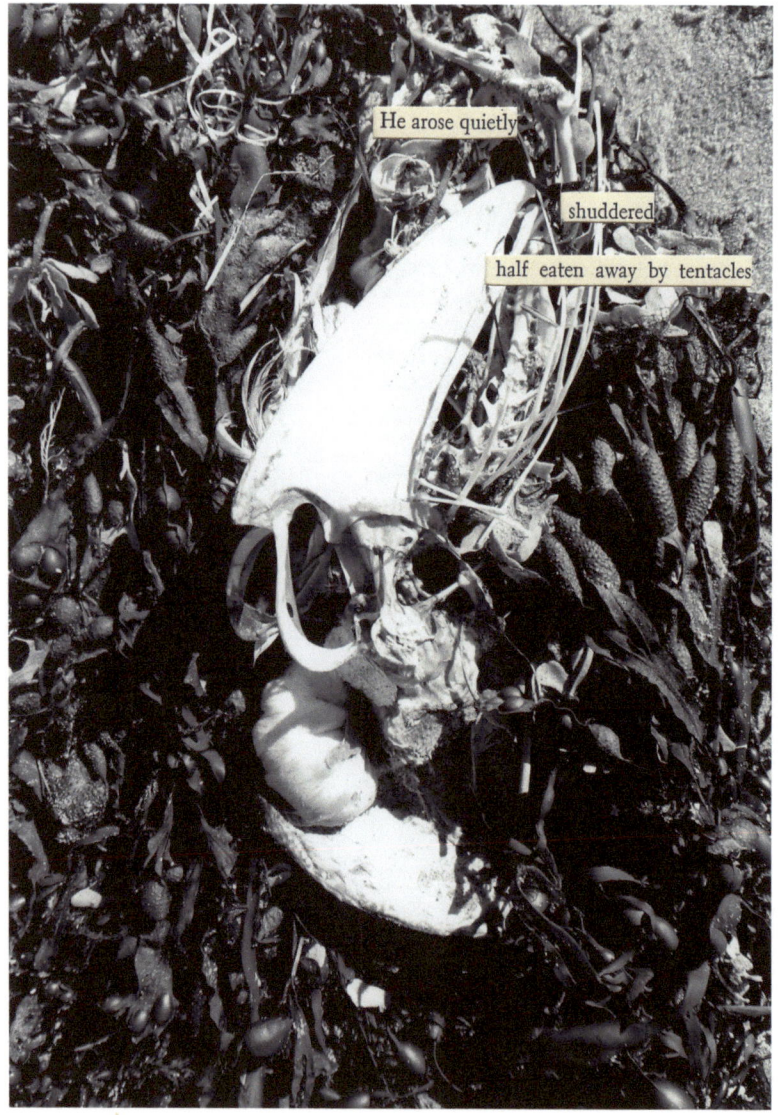

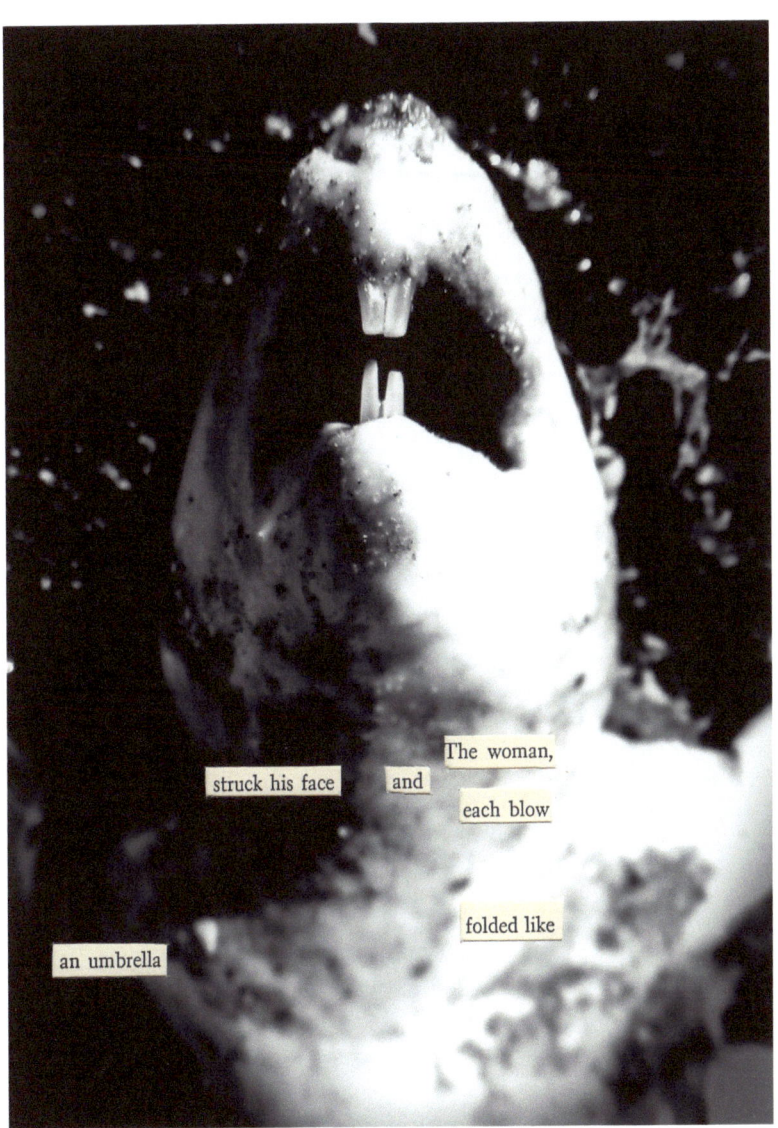

struck his face and The woman,
each blow

folded like

an umbrella

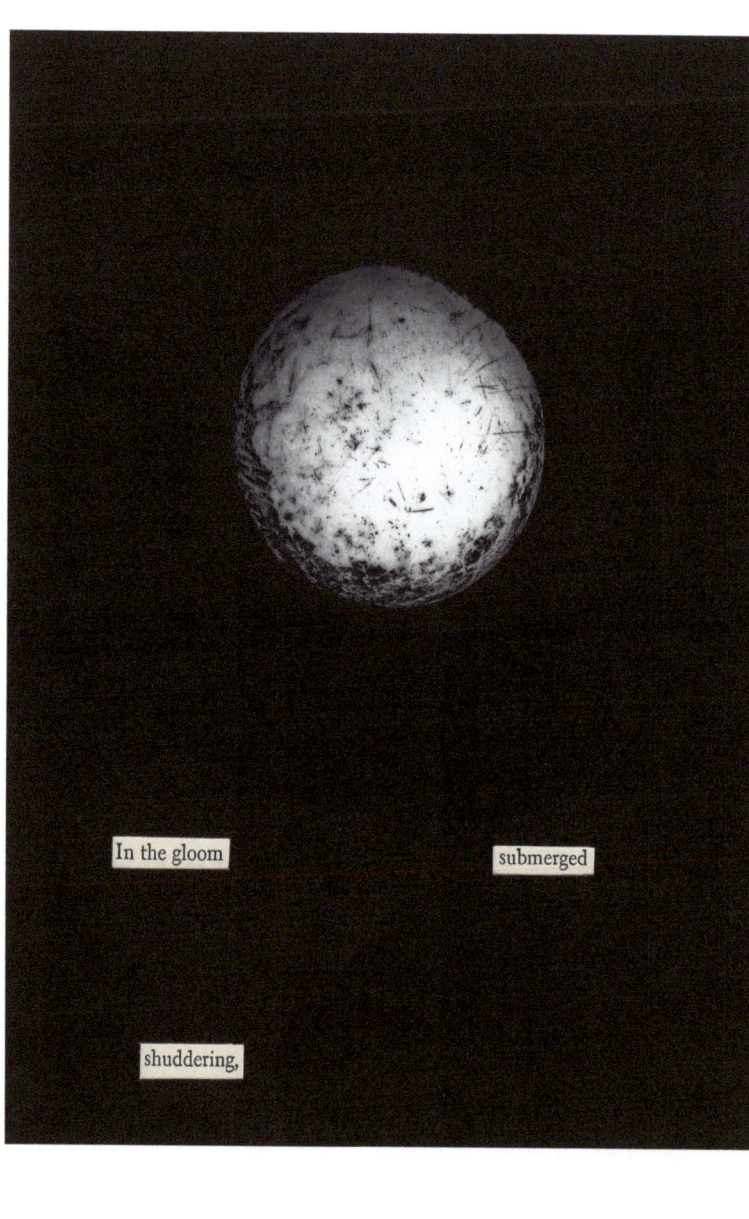

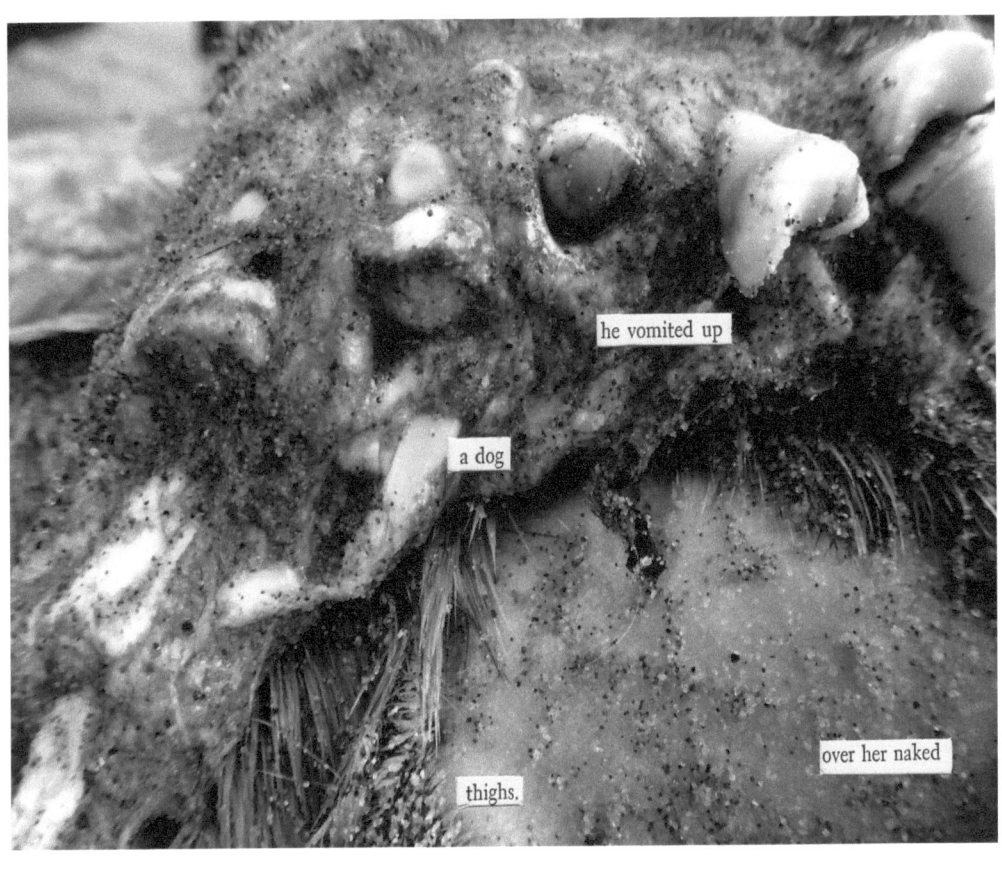

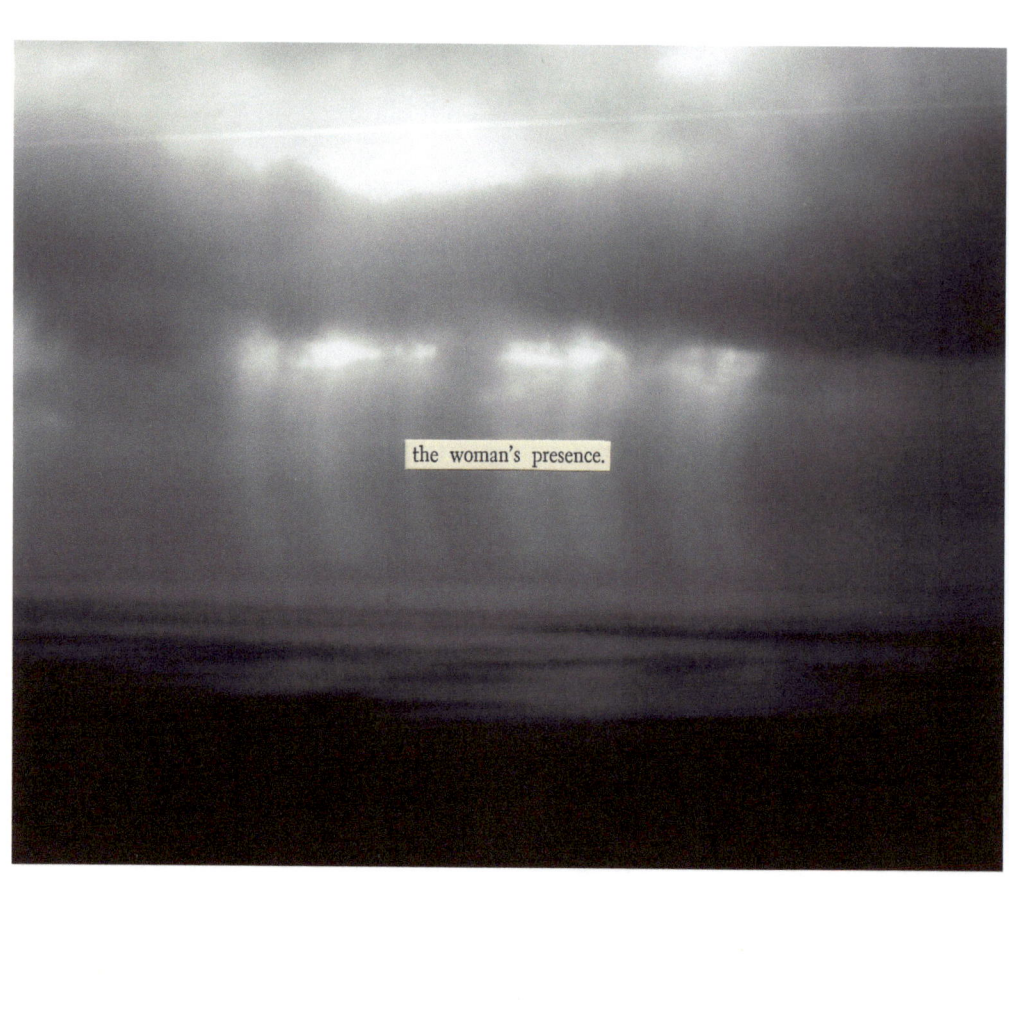

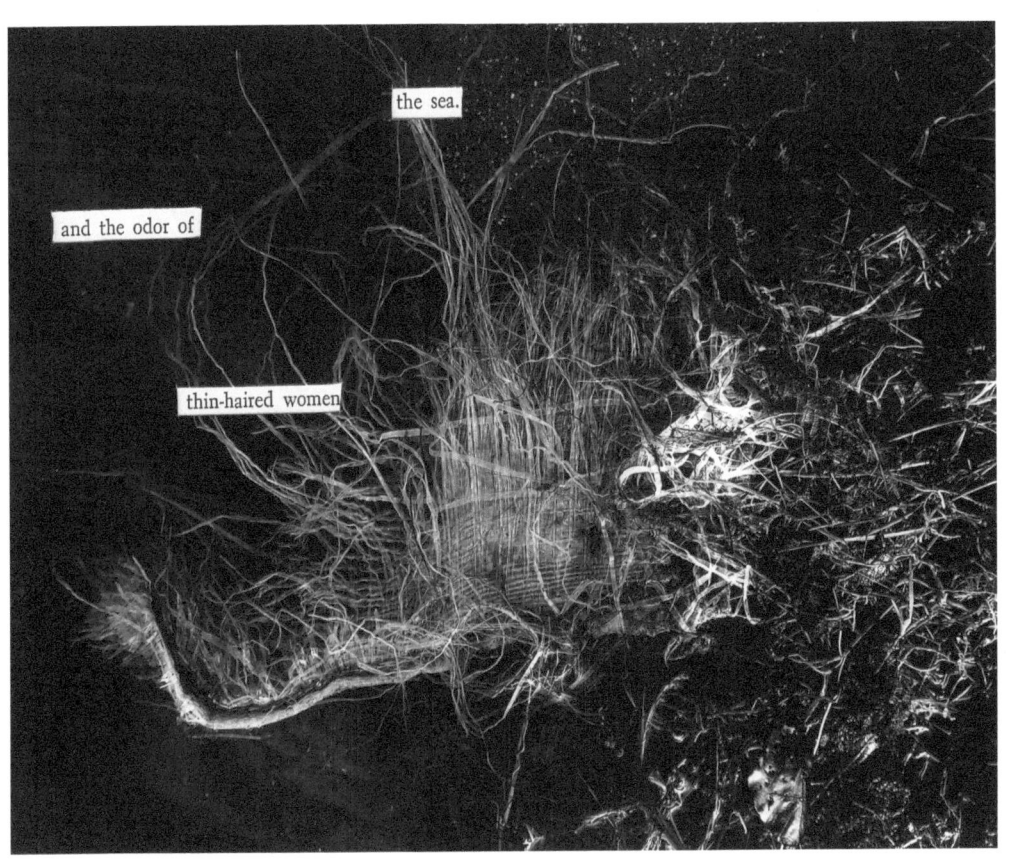

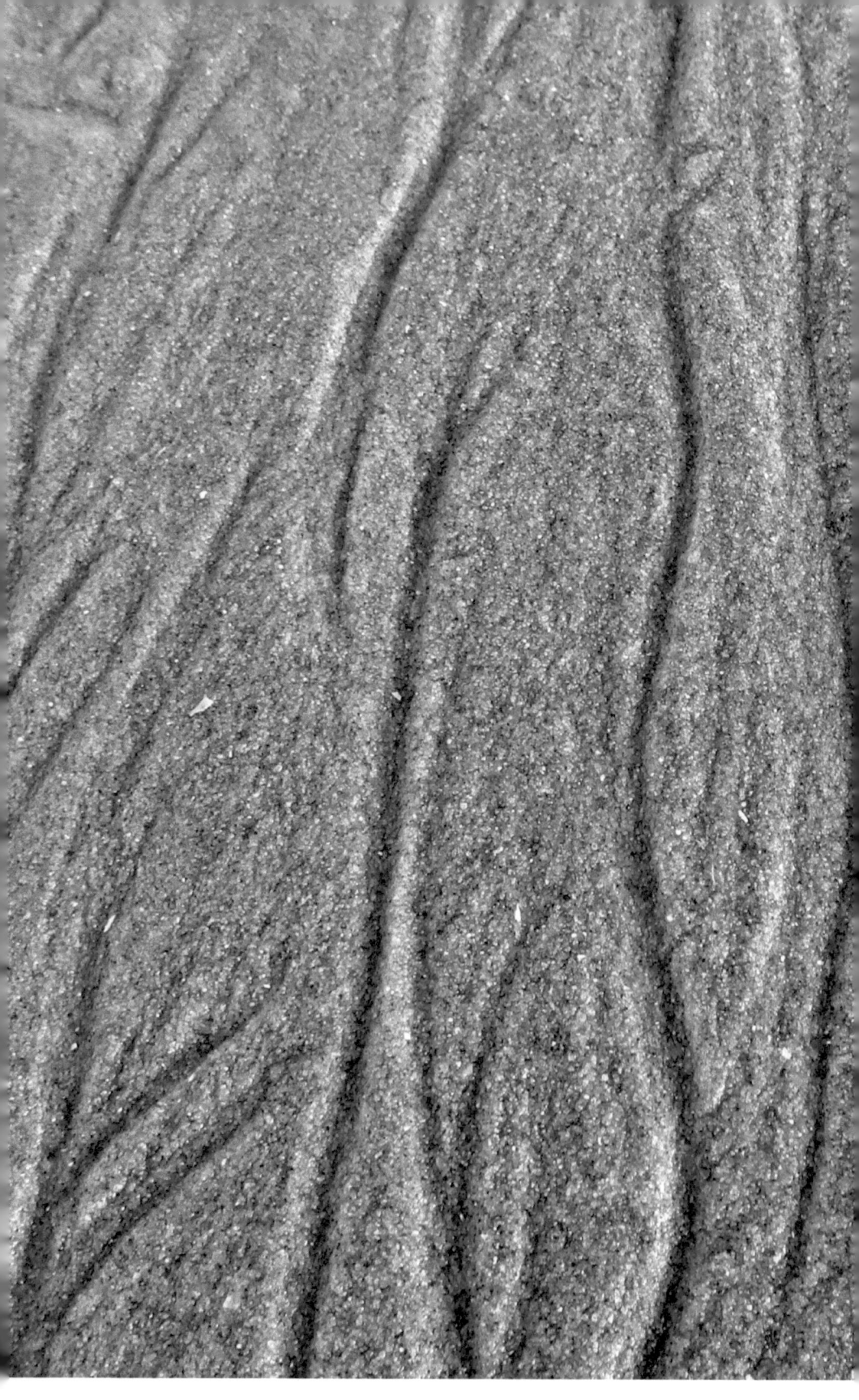

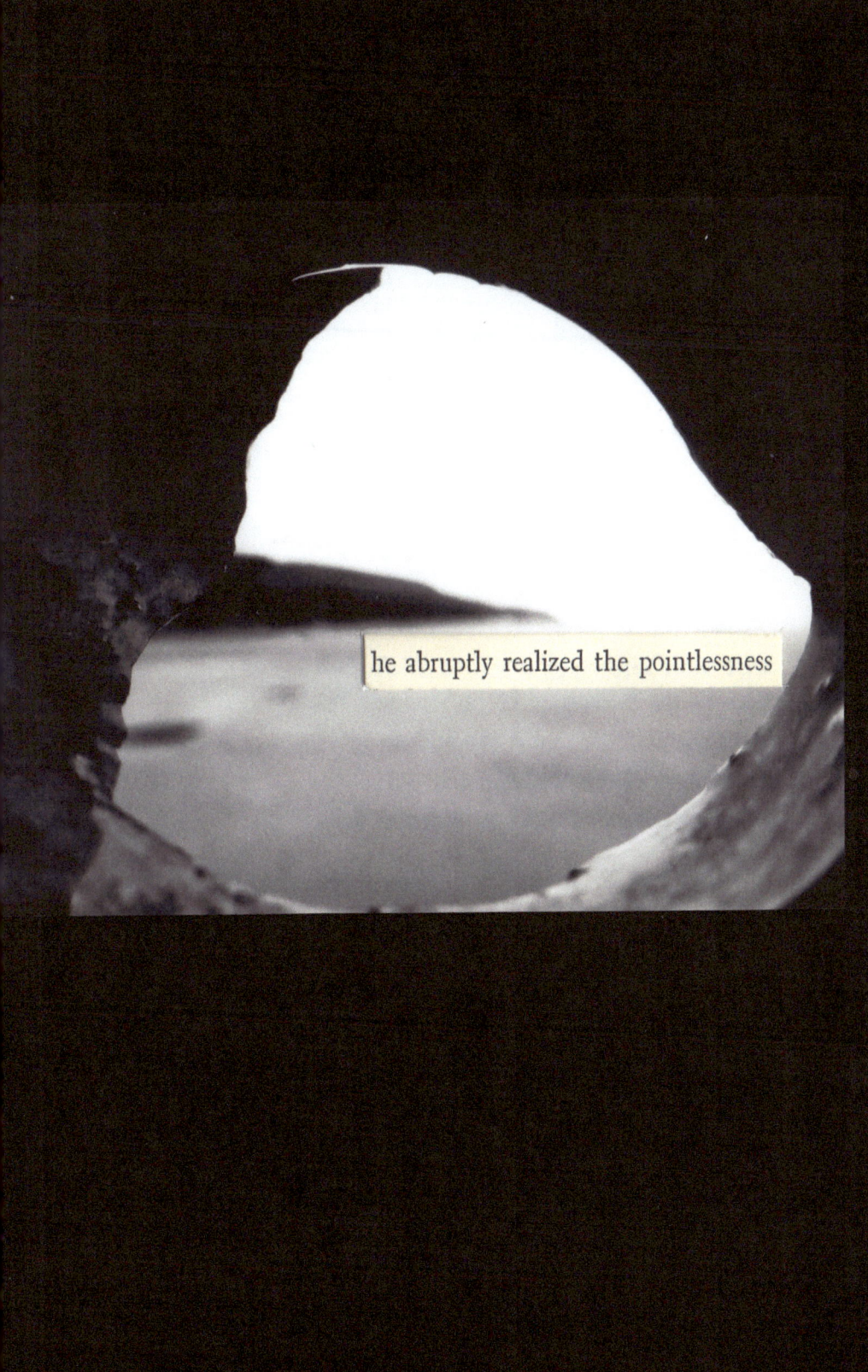

www.ingramcontent.com/pod-product-compliance
Lightning Source LLC
Chambersburg PA
CBHW041210180526
45172CB00006B/1228